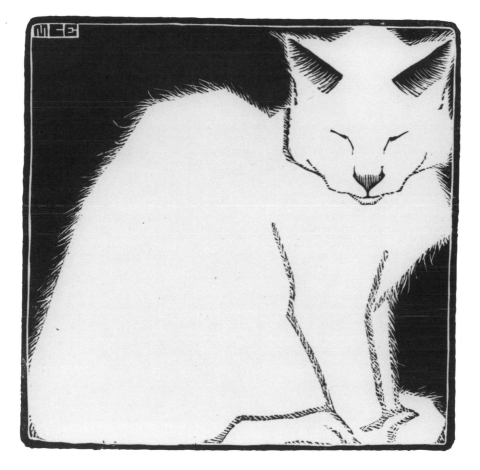

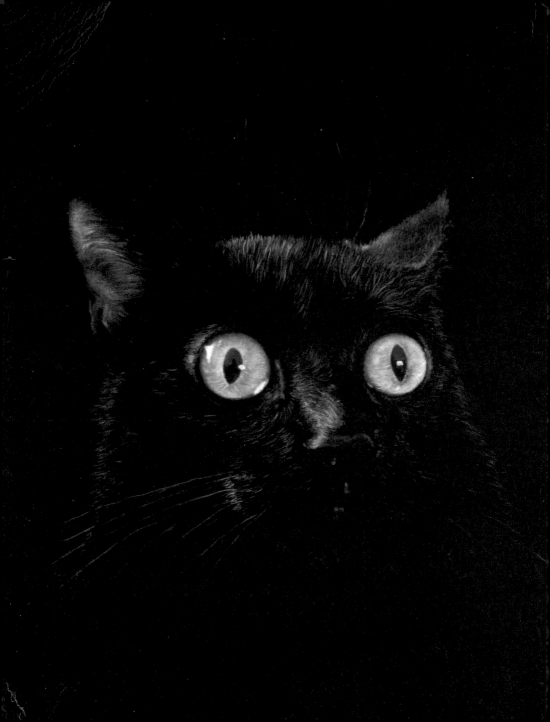

THE BOOK OF THE

Angus Hyland & Caroline Roberts

LAURENCE KING PUBLISHING

'THERE ARE NO ORDINARY CATS.'

COLETTE

It's often said that cats are creatures that domesticated themselves – as soon as humans began to settle in one place and store grain, the feline pest controllers soon followed and made themselves at home. It's the domestic situation in which cats are often captured in paintings because it's the place that is the common ground between cats and humans. Cats are unusual as they are the only domestic creatures that come and go exactly as they please. Away from their homes they lead another, entirely secret life that we know nothing about, returning for food, shelter and (if you're very privileged) a comfortable lap to sit on.

While this might sound rather mercenary, it goes some way to explaining the unique relationship between cats and humans. Whereas most pets are entirely dependent on their humans, cats are not, and some (invariably non-cat-loving) people find this difficult to accept. As Jeffrey Moussaieff Masson points out: 'We need cats to need us. It unnerves us that they do not. However, if they do not need us, they nonetheless seem to love us.' This mutual love story is evident in lots of the artworks featured here, with many of the artists immortalizing their own beloved feline friends on canvas or on paper.

Cats are not stupid though, and, like a Jane Austen heroine, their affections are not easily won. They need to be wooed (preferably with flattery and delicate morsels) and will return your attentions as and when they see fit. This drip-feed of affection sees these canny creatures steadily but surely worm their way into our hearts. While it's often said that the dog is 'man's best friend', it could be argued that the relationship between cat and human, while equally as strong, is something quite different. Cats seem to delight in keeping us guessing, but that just seems to add to their appeal. As Hazel Nicholson neatly puts it, 'A cat is a puzzle for which there is no solution.'

'I BELIEVE CATS TO BE
SPIRITS COME TO EARTH.

A cat, I am sure

COULD WALK ON A

CLOUD

WITHOUT COMING THROUGH.'

JULES VERNE

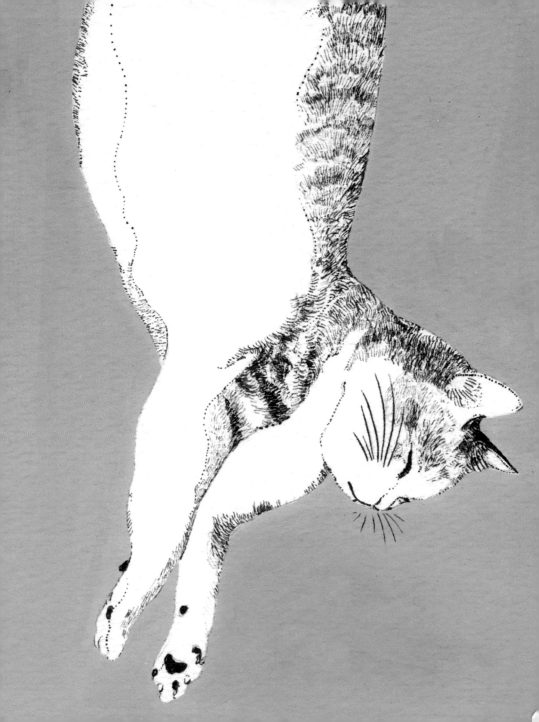

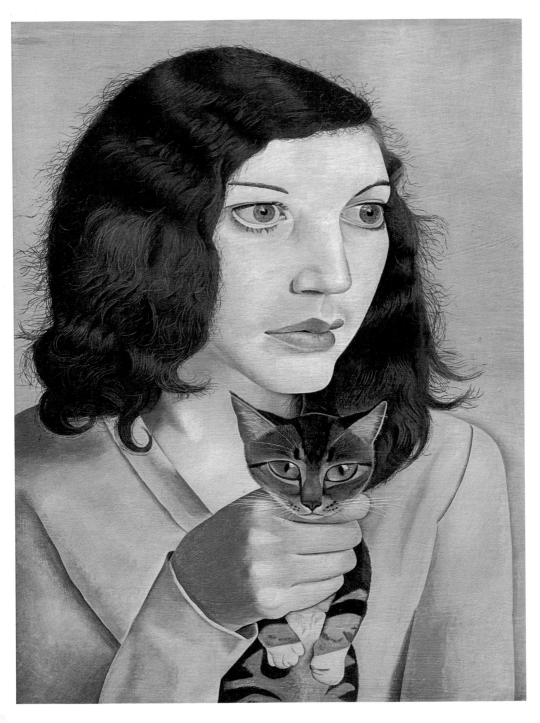

LUCIAN FREUD

Girl with Kitten

1947

The anonymous 'girl' referred to in the title is Freud's first wife Kitty, who was twenty-one when she sat for this rather disturbing portrait. If not actually being strangled, then the sitter's white knuckles suggest that this poor kitten is being held just a little too tightly for comfort. The pair met when Freud had an affair with Kitty's aunt, and although painted in the early days (before their five-year marriage ended due to Freud's alleged womanizing), Kitty's mildly terrified expression doesn't exactly exude matrimonial harmony. While Kitty stares fixedly out of the frame, the kitten – despite perhaps being in the very early stages of asphyxiation – isn't afraid to face the artist (who freely admitted to a certain 'visual aggression' towards his subjects) head on, staring defiantly into the painter's legendary piercing blue eyes.

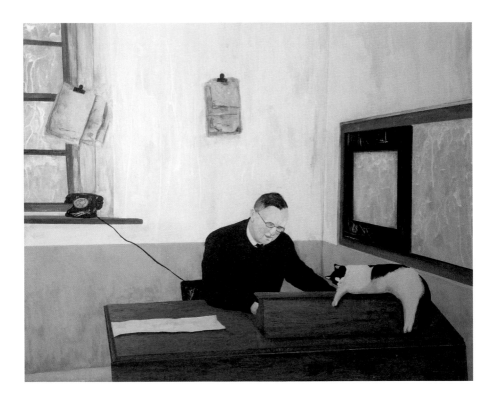

Yi-Shiang Yang, *Desktop Business—Accompany*, 2013

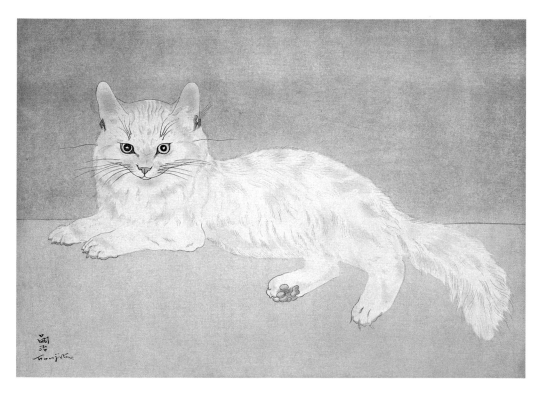

Tsuguharu Léonard Foujita, *White Cat*, c. 1920

THE

SHAPE

OF A CAT'S TAIL
IS OFTEN
A GOOD INDICATOR
OF WHAT'S

on his mind.

But not always.

Saul Steinberg, *The Paris Review?*, 1967

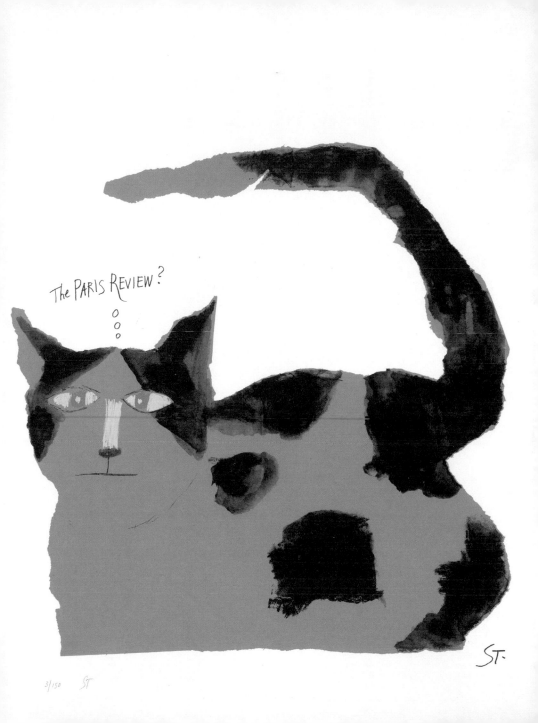

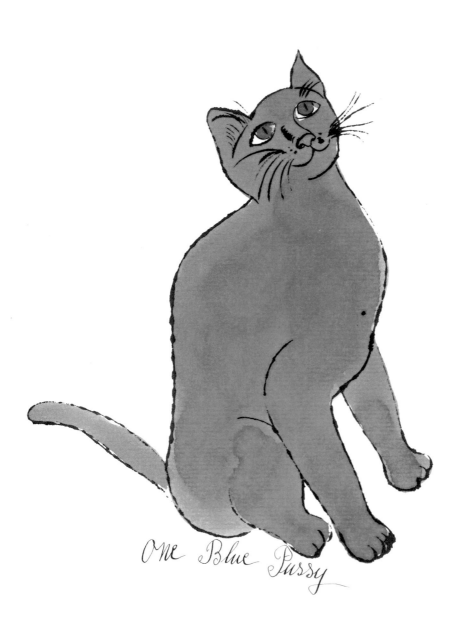

One Blue Pussy

ANDY WARHOL WAS
VERY FOND OF

MULTIPLES

HE HAD

TWENTY-FIVE

CATS CALLED SAM.

AND *ONE* THAT WASN'T.

Andy Warhol, *One Blue Pussy*, 1954

'Cats are connoisseurs of comfort.'

JAMES HERRIOT

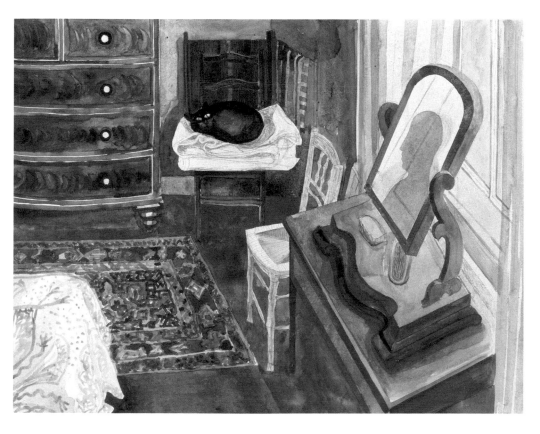

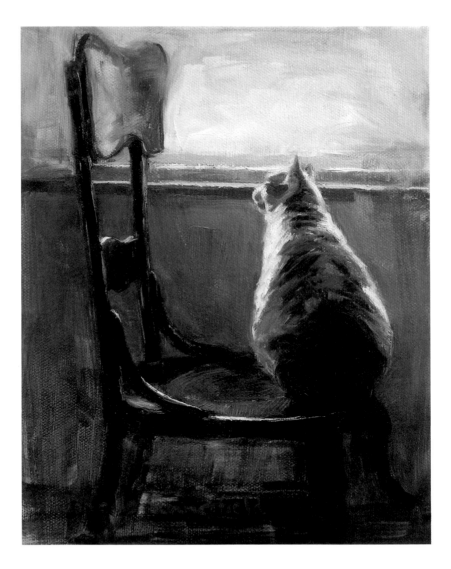

ABOVE: Jonelle Summerfield, *On the Edge of His Seat*, 2014
OPPOSITE: Marcel Schellekens, *Cat on a Chair*, 1995

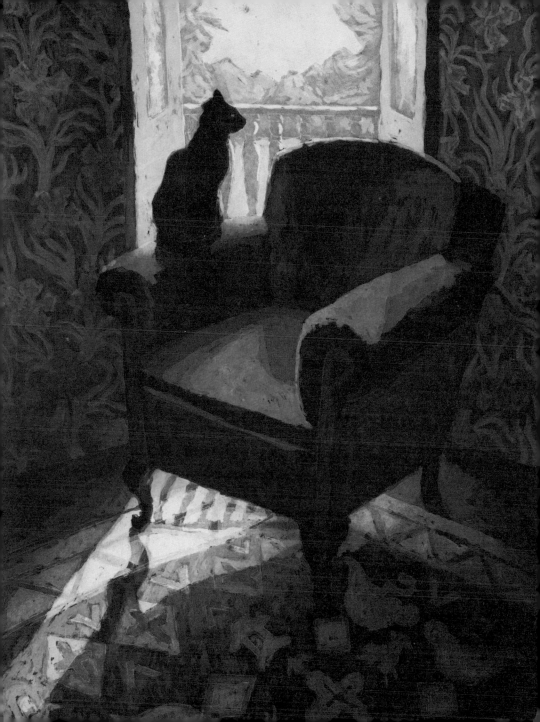

DAME ELIZABETH BLACKADDER

Cat on a Silk Cushion

2010

Dame Elizabeth Blackadder holds the accolade of being the first woman to be elected to both the Royal Scottish Academy and the Royal Academy, but it is her timeless Japanese-influenced still-life paintings full of plants and flowers, and her beautifully observed studies of her beloved cats, that have earned her a place in the nation's heart. Blackadder's paintings also earned her another first – in 1995 they appeared in the first set of UK postage stamps to include cats. The 41p stamp stars Blackadder's black and white cat Fred lounging luxuriously on an orange silk cushion, while the 19p stamp features black cat Sophie sitting next to an enormous lily, giving HRH a daggers look – probably because she's just been told by the monarch not to eat the bunch of beautiful (but highly toxic to cats) flowers.

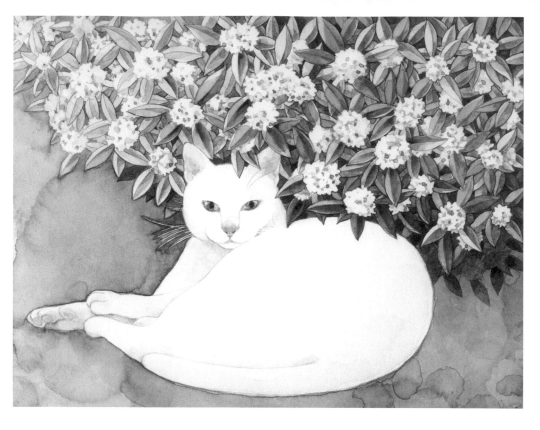

ABOVE: Midori Yamada, *Rissyun* (*Beginning of Spring*), 2011
OPPOSITE: Midori Yamada, *Karasuuri* (*Japanese Snake Gourd*), 2010

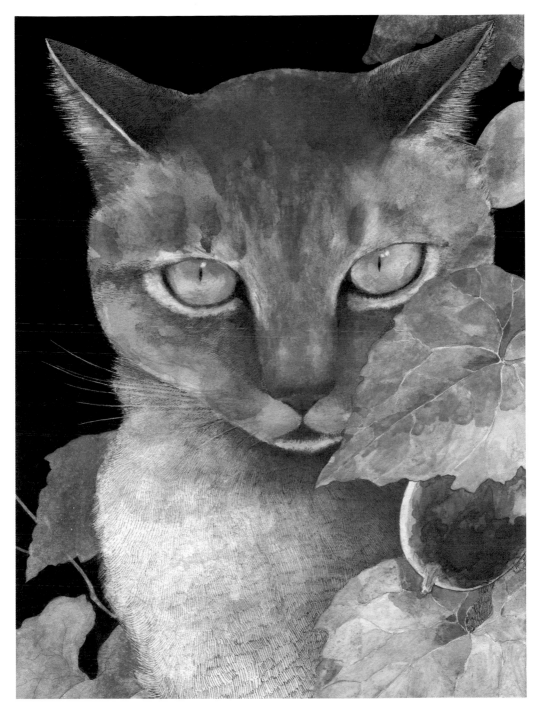

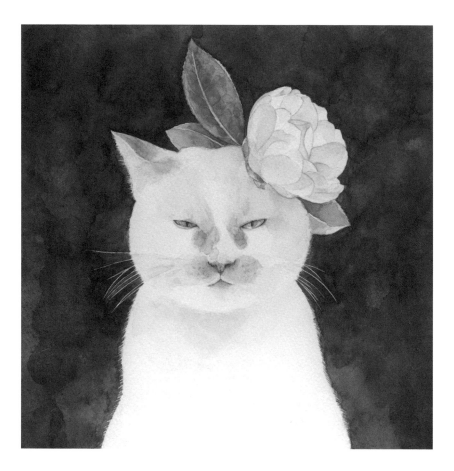

ABOVE: Midori Yamada, *Suri-tsubaki (White Camellia)*, 2010
OPPOSITE: Midori Yamada, *Hyakken-sensei no neko (Mr Hyakken's Cat)*, 2011

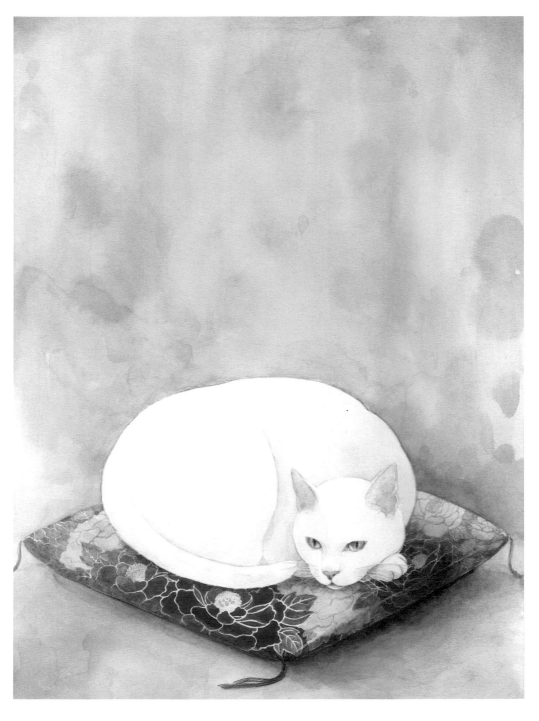

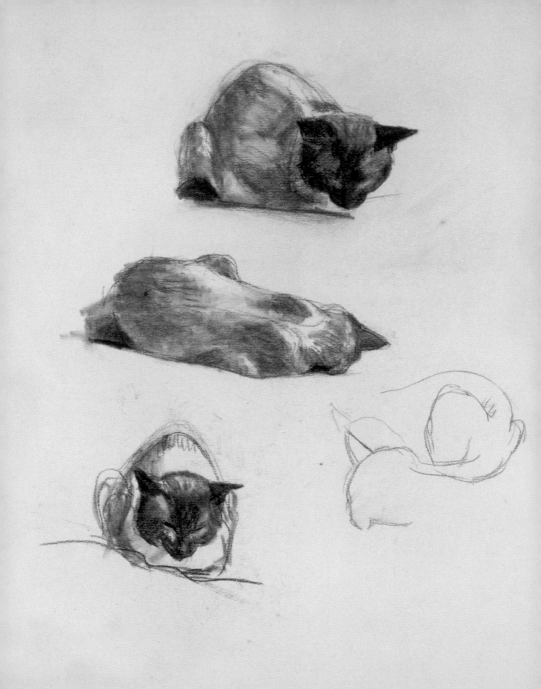

Edward Hopper, *Cat Study* (detail), 1941

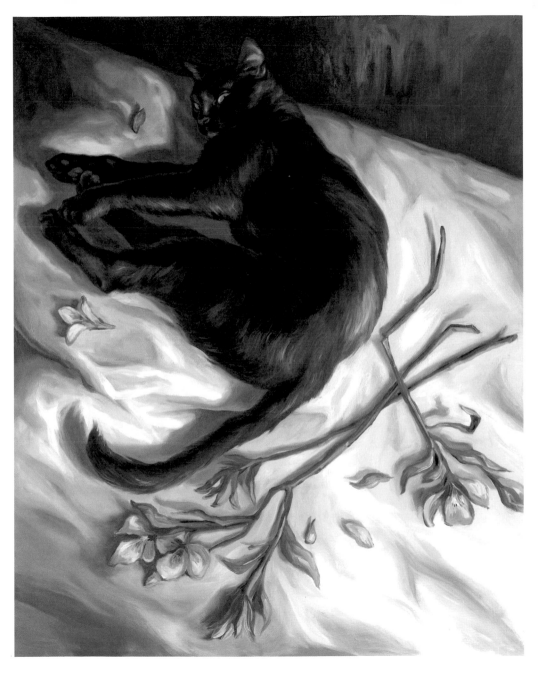

Owen Smith, *Jilt*, 2012
FOLLOWING PAGES: Jane Crowther, *Black Cat*, 2010, and *Black Cat*, 2002

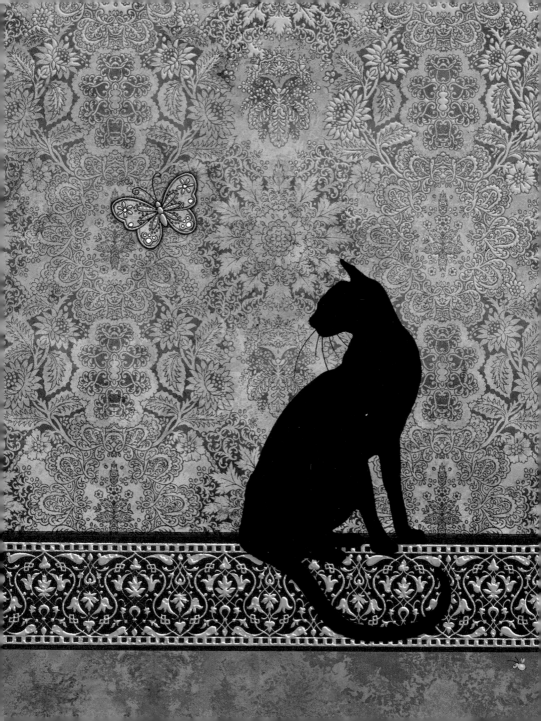

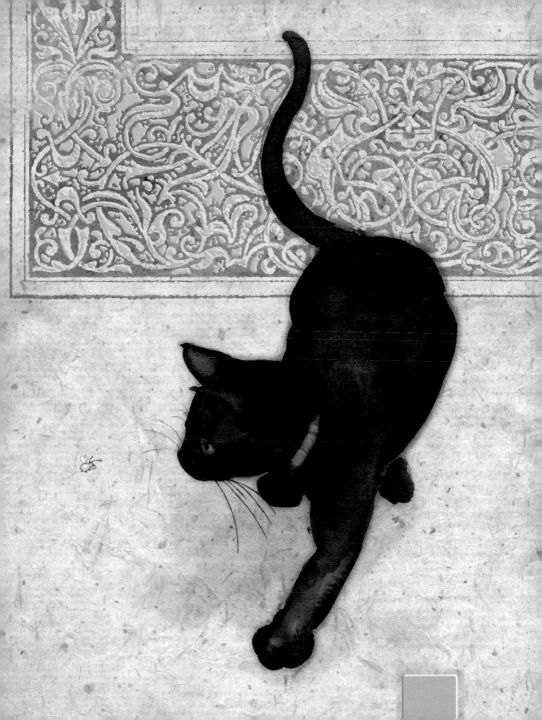

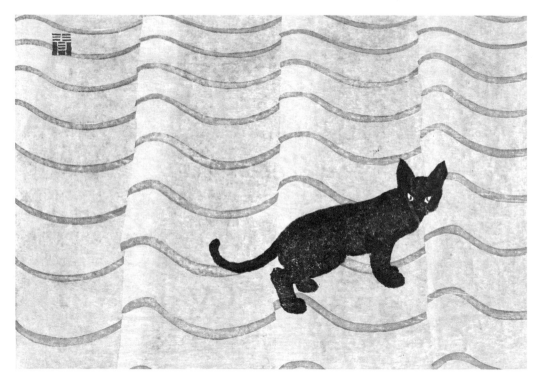

ABOVE: Aoyama Masaharu, *Cat on a Roof*, 1950s
OPPOSITE: David Konigsberg, *Mary Steals By*, 2010
FOLLOWING PAGES: Midori Yamada, *Oide (Come)* and *Furui-ki (Old Tree)*, 2010

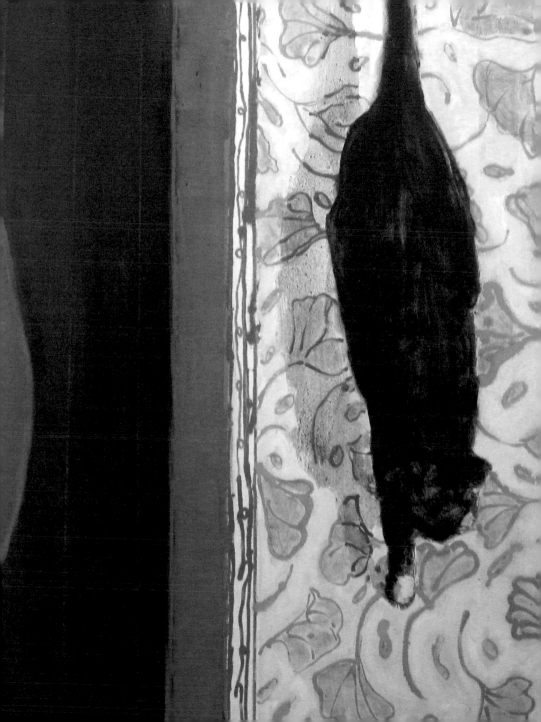

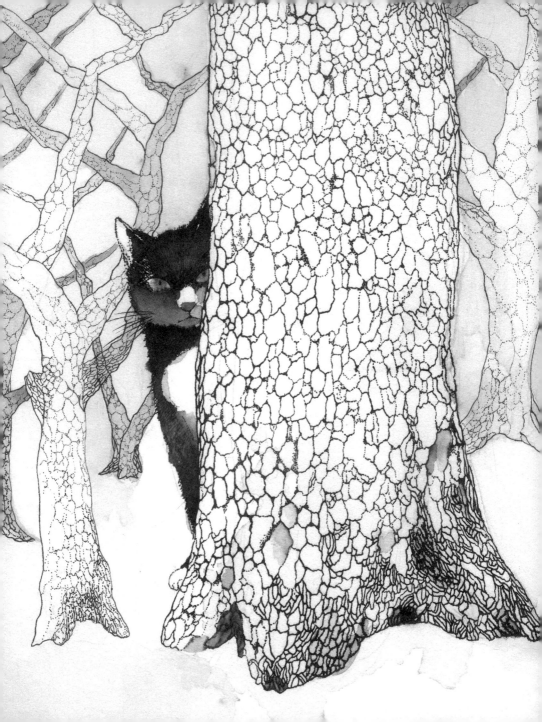

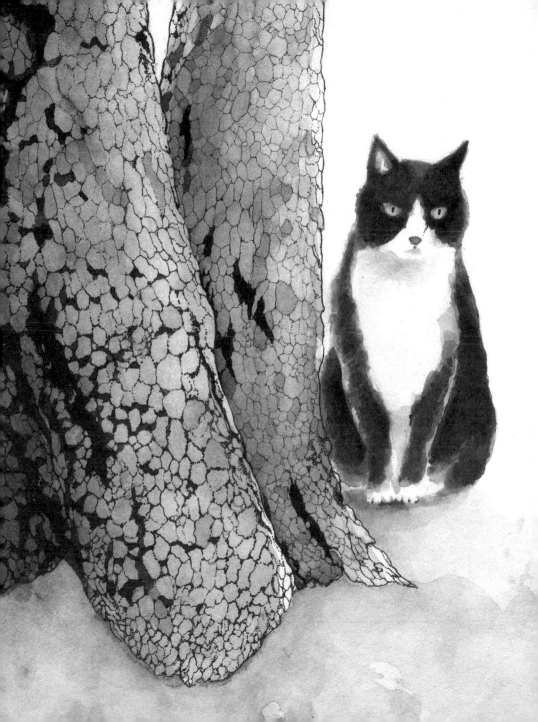

'A cat is a lion in a jungle of small bushes.'

INDIAN PROVERB

Midori Yamada, *Hiyodori (Brown-eared Bubul)*, 2011

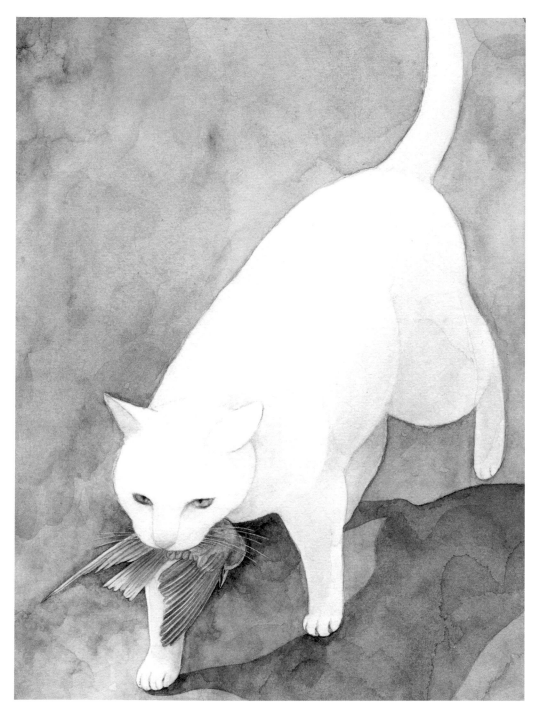

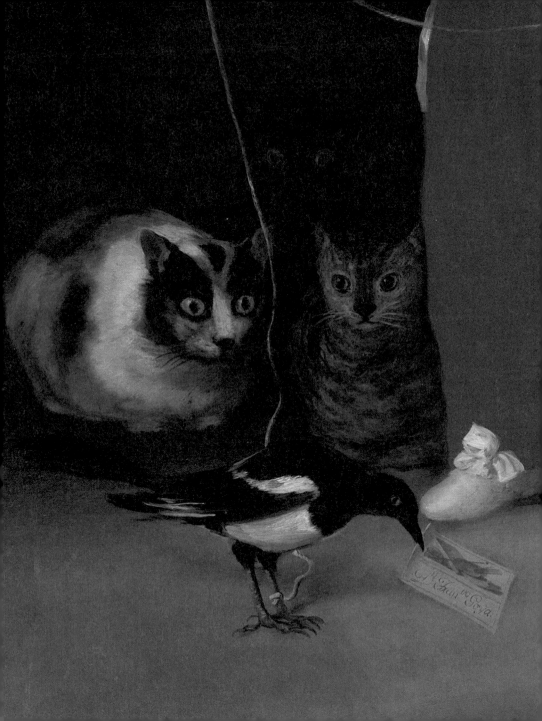

FRANCISCO GOYA

Manuel Osorio Manrique de Zuñiga (detail)

c. 1790

Rife with symbolism, Goya's portrait is of the son of one of Spain's foremost intellectual families, who died at the tender age of eight. Cats appear in many of Goya's paintings, but he often portrays them as wild creatures, predatory, snarling and mid-fight. At first glance it would appear that there are two cats here, but look closer and there's a third lurking in the darkness behind the other two. Anyone familiar with the origins of the phrase 'herding cats' will smile at the notion of three cats sitting patiently together while a bird is paraded inches from their noses. The dark humour continues with the first cat's cartoon-like eyes, which look like they're about to burst Tom and Jerry-style from their sockets. The painting is hung in the Metropolitan Museum in New York – perhaps as a reminder to subsequent generations of children of how easy they have it now, not being trussed up in a lace-trimmed red velvet suit with only a magpie on a string, some caged finches and a trio of bug-eyed cats for company.

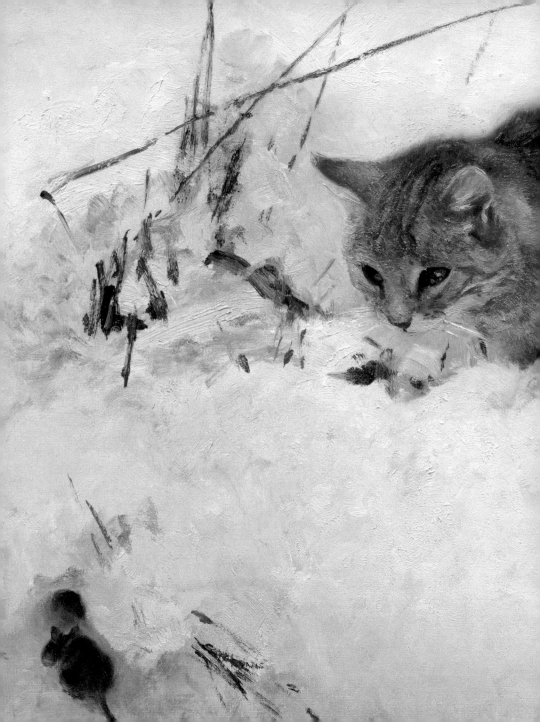

THIS SWEET LITTLE

sparrow

IS WHAT YOU
MIGHT CALL

'living dangerously'.

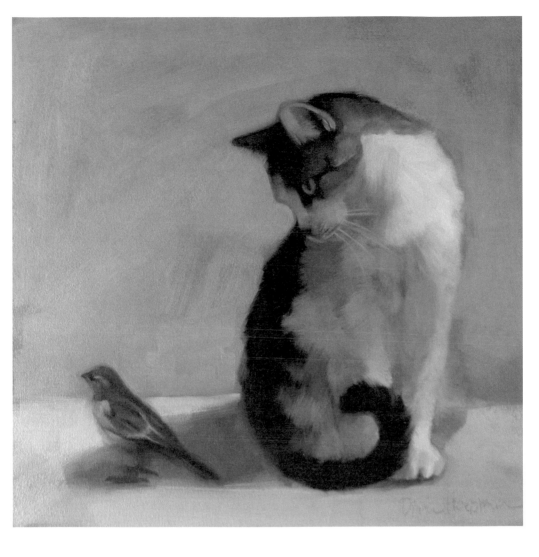

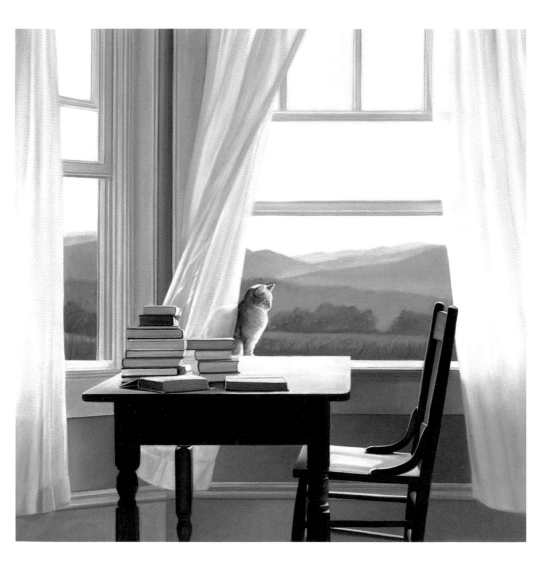

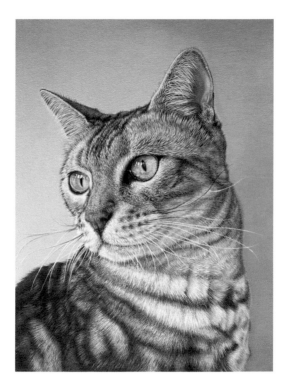

ABOVE: Sara Butt, *Handsome Chap (Arty)*, 2015
OPPOSITE: Karen Hollingsworth, *Connected*, 2010

DAVID HOCKNEY

Mr and Mrs Clark and Percy

—————————————— 1970–71 ——————————————

A hugely popular portrait that hangs in Tate Modern in London, the Mr and Mrs Clark in question are Hockney's friends, the celebrated fashion designer Ossie Clark and his textile-designer wife Celia Birtwell. The portrait was set in the bedroom of the Clarks' Notting Hill Gate flat – Hockney preferred the light in there but staged it to look like it was the living room. This is not the only thing that isn't quite as it seems. The Clarks owned two white cats – Percy and his mother Blanche, who lived to the ripe old age of twenty-two. Percy was the bigger of the two (described affectionately by Celia as being a bit of a lump and not very bright), while Blanche was an elegant lady cat, with more refined and delicate features. It's actually Blanche who is perched so gracefully on Ossie's knee, staring intently out of the open window. However, Hockney felt that 'Mr and Mrs Clark and Blanche' didn't have quite such a good ring to it, so the artifice continued.

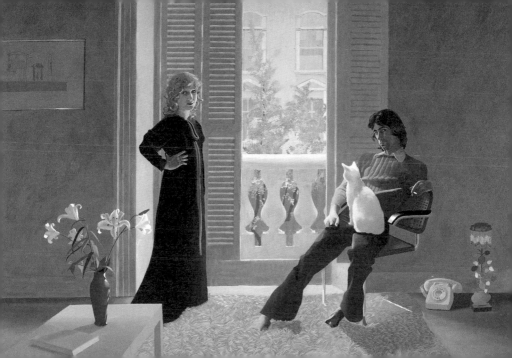

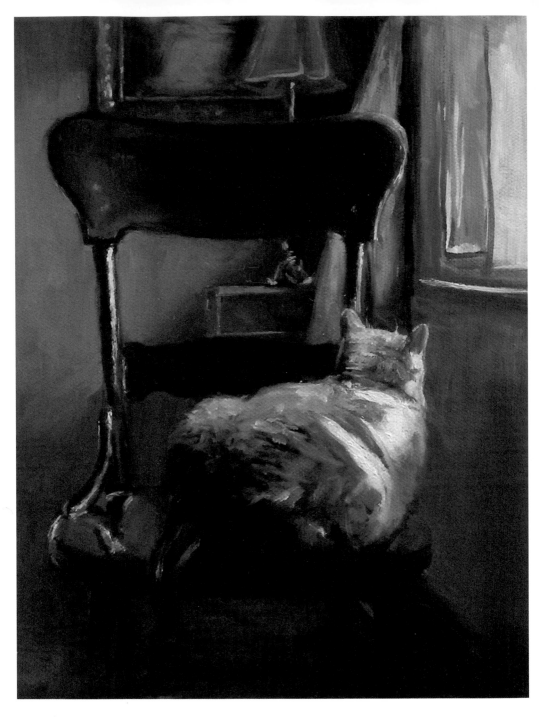

'For a man to truly understand *rejection*,
he must first be ignored by a cat.'

ANONYMOUS

Jonelle Summerfield, *Birdwatching*, 2014

FRANZ MARC

The White Cat

One of the rising stars of the European avant-garde before he was killed in action in World War I, Marc painted many different animals – including horses, foxes, tigers and deer – throughout his short career. His colourful paintings have an almost magical quality, showing his obvious love and appreciation of the animal kingdom in its many shapes and sizes. Marc's white cat is in a classic sleeping pose, although one ear is still pricked, listening out for danger. We don't get to see the cat's eyes, but white cats can have either orange or blue eyes, or a combination of both. If they were both blue then there would be a very high chance that the white cat would be deaf. And if one eye was blue and one was orange, then there would be a very high chance that the cat in question would be called Bowie.

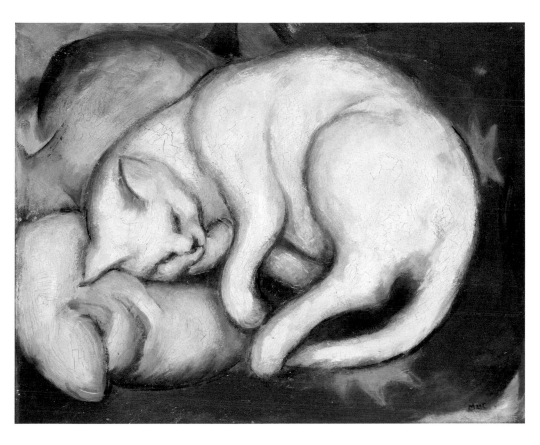

Ruskin Spear, *Cat and Canaries*, late 1980s

SEBASTIANO LAZZARI

Still Life with Cat

c. 1770

Those who have yet to fully understand how a cat's mind works might mistakenly assume that this cat is stealing a piece of cured meat from the Venetian master's opulent still-life arrangement. This is not the case. In the same way that cats have no time for our concept of doors (they see them purely as an obstacle that has been inconveniently placed in their way), cats have no concept of possessions. What's yours is theirs, and if they wish to eat, play, destroy or just sit on it then they will, whether you like it or not. And whereas a dog will know when he has incurred the wrath of his human and act suitably contrite, if reprimanded, a cat will simply give you a filthy look and flounce off, muttering 'Well, what do you expect if you leave a plate of top-grade salami uncovered on the table?'

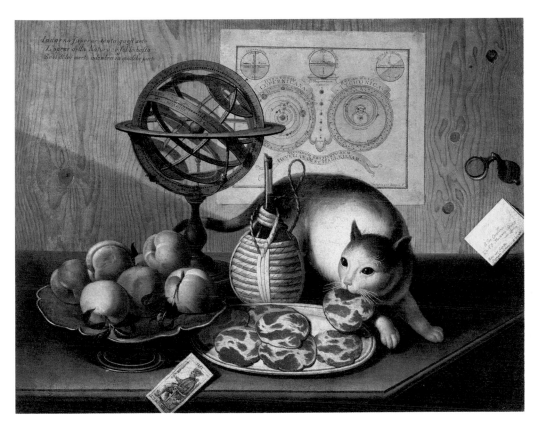

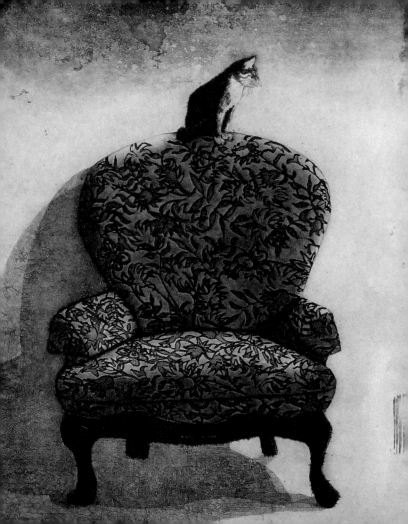

Larry Welo, *Deja Vu*, 2002

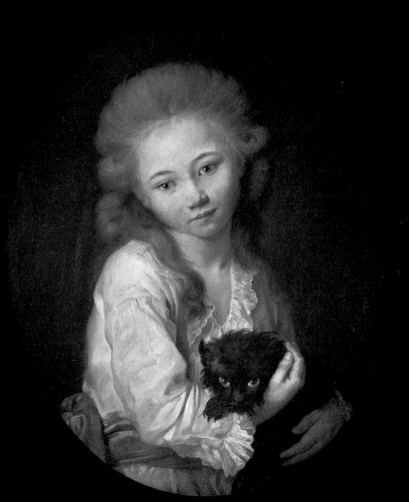

ABOVE: Théophile Alexandre Steinlen, *A Small Girl with a Cat*, 1889
OPPOSITE: Jean-Baptiste Greuze, *Esprit de Baculard d'Arnaud*, 1776

'YOU ARE

my cat

AND I AM

your human.'

HILAIRE BELLOC

OPPOSITE: Norma Bessouet, *Family Portrait*, 2012
FOLLOWING PAGES: Sebastiano Ranchetti, *Stylish Cat*, 2010; *Black Cat*, 2009;
and *Blue Cat*, 2005

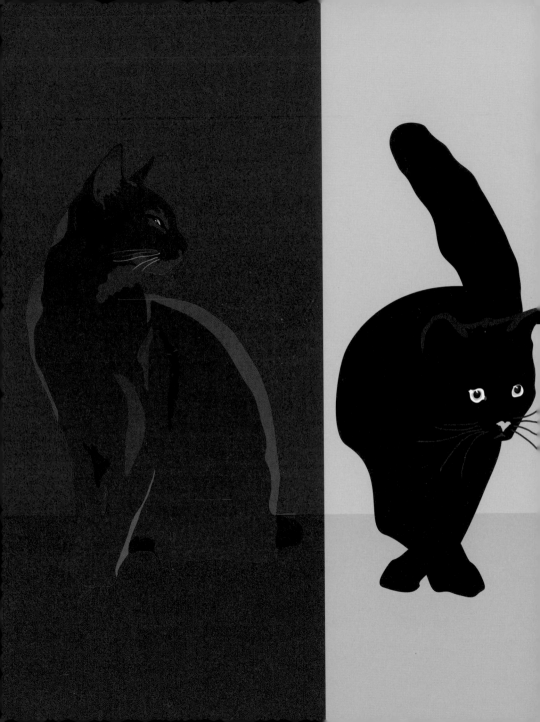

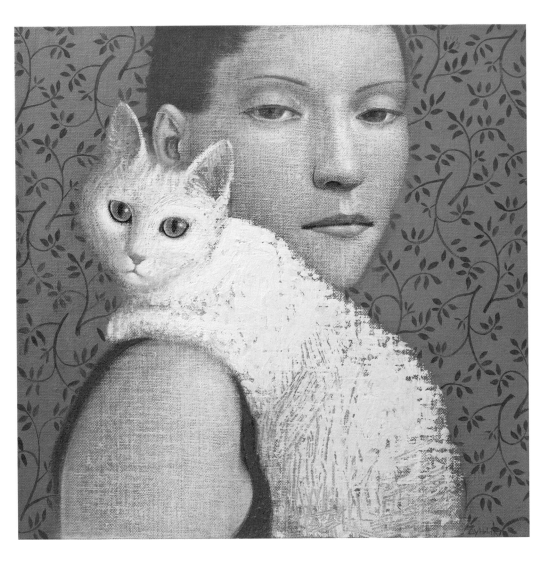

Vladimir Dunjić, *The Seventh Life*, 2009

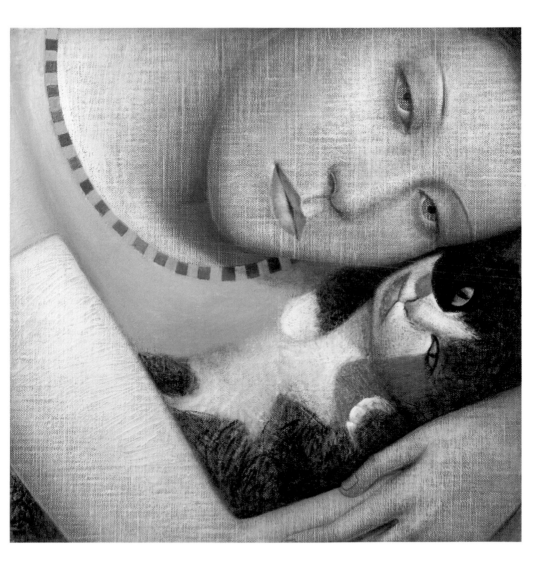

Vladimir Dunjić, *The Fourth Life*, 2008

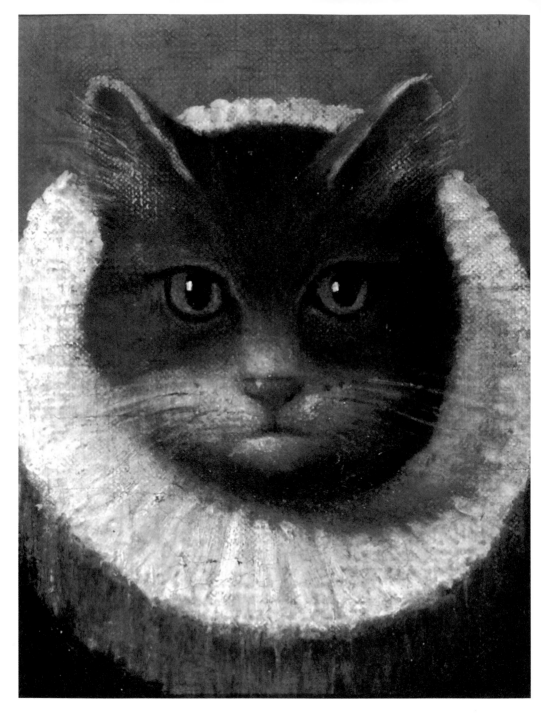

ANONYMOUS

Cat in the Ruff

LATE 19TH CENTURY

Mark Twain (aka Samuel Clemens) loved to be surrounded by felines. One of his friends noted that Twain 'could scarcely meet a cat on the street without stopping to make its acquaintance', and he is well known for stating that 'When a man loves cats, I am his friend and comrade, without further introduction.' This oil painting of unknown origin resides on the mantelpiece in the library of the Twain family home in Connecticut. Twain's young daughters would demand that the writer invent stories for them – these whimsical tales included all the items on the mantelpiece, but always started with the 'Cat in the Ruff' and finished with a watercolour of a girl called Emmeline. Twain saw cats as equal, if not superior, to humans. One of his daughters, Clara, remarked that if it was necessary to interrupt her father when he was working, it was 'expedient to be accompanied by a kitten'.

ANONYMOUS

Cat and Kittens

c. 1872/1883

It's hard to look at this naive American folk-art family ensemble without being drawn back to the wide, staring eyes of the mother cat. Many people feel very unsettled when they find themselves the subject of a cat's unflinching gaze, but, unlike humans, cats don't need to blink to keep their eyes lubricated. What humans perceive as staring – along with all of its negative connotations – is simply a behaviour that we project onto our feline friends. And as most cat owners soon realize, any attempt to out-stare your cat is sure to end in failure. It's a much better idea to acknowledge their infinite superiority and attempt to ingratiate yourself by squinting intermittently, a conciliatory action that he or she may – or may not – deign to return.

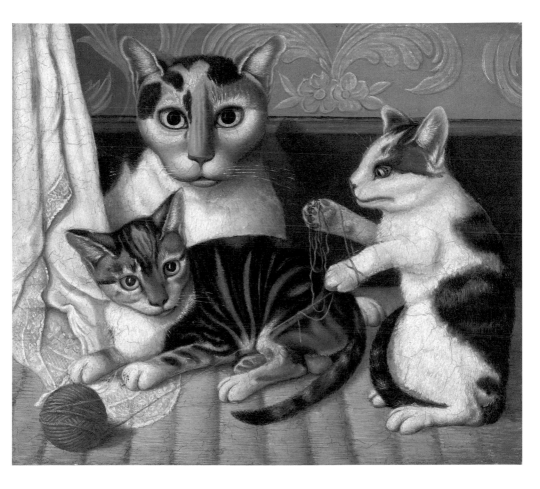

Edward Bawden, *Off to Windmill Hill*, 1980s

'YOU WILL ALWAYS

BE LUCKY

IF YOU KNOW
HOW TO

MAKE FRIENDS

WITH *STRANGE CATS.*'

PROVERB

Utagawa Kuniyoshi, *Fifty-five Cats Representing
the Fifty-three Stations of the Tokaido* (detail), c. 1850

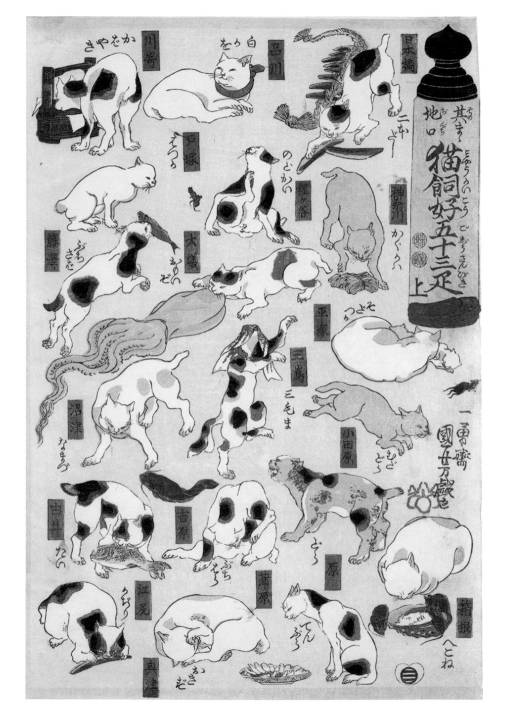

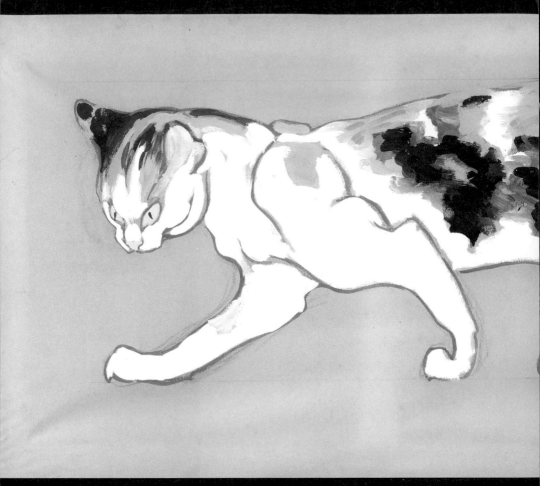

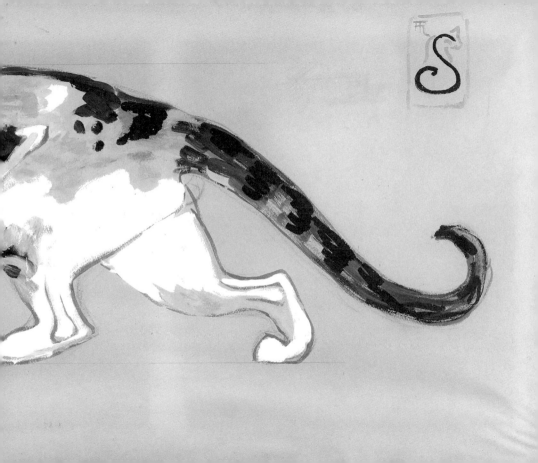

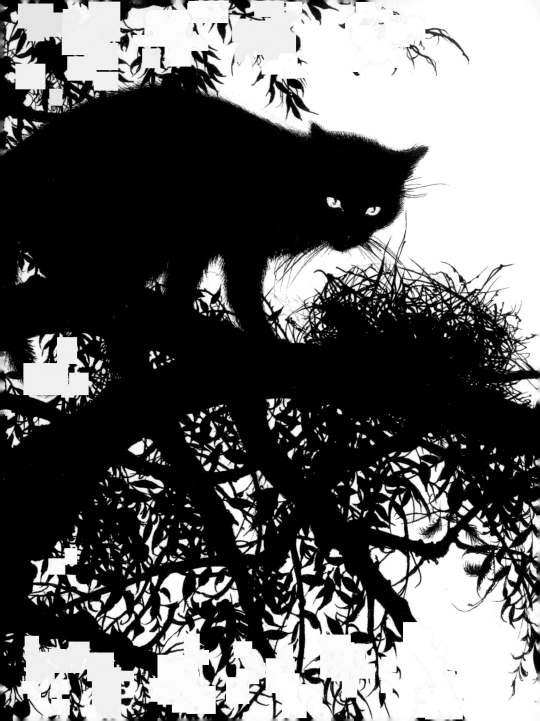

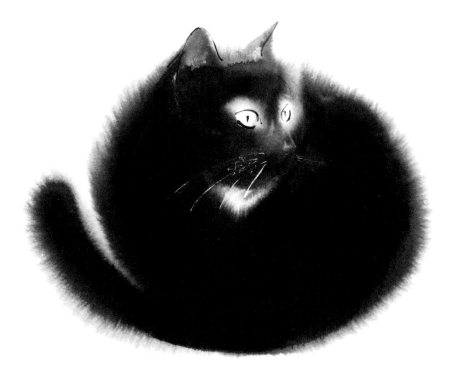

Endre Penovác, *Still*, 2015

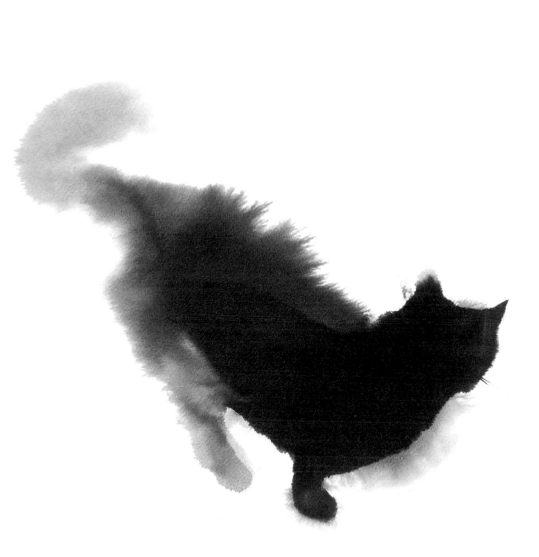

Endre Penovác, *Waiting*, 2013

LEONARDO DA VINCI

Study of a Child with a Cat

c. 1478–81

Was there anything that the original Renaissance Man couldn't draw? Well, it would seem that the combination of determined toddler and unimpressed cat proved quite a challenge, even for someone with Leonardo's brilliant pen and ink skills. Things start off well with the drawing in the centre of the page, but the sketches above and below tell a different story, with the toddler desperately trying to wrestle the cat into submission and Leonardo's lines becoming more and more sketchy. These were created for the proposed painting *The Virgin and Christ Child with a Cat*, of which only the various studies exist, housed in the collection of the British Library. There would appear to be no record of an actual painting, so maybe Leonardo decided that a scene showing the Baby Jesus struggling with an animal that isn't actually mentioned in the Bible wasn't such a good idea after all?

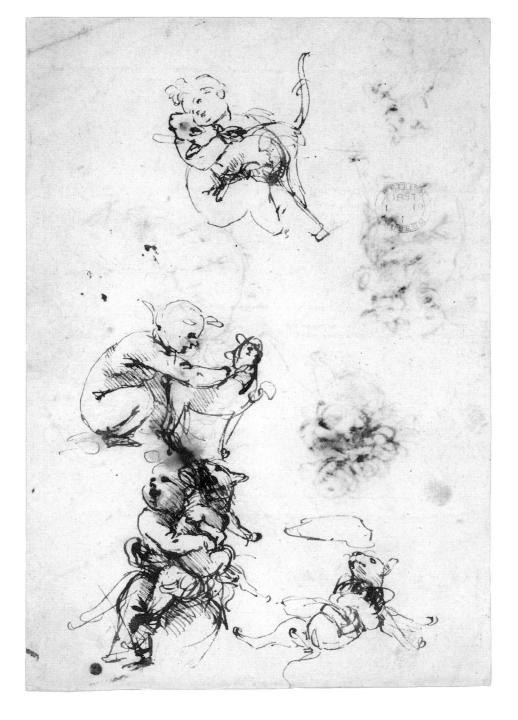

ABOVE: Kay McDonagh, (clockwise from top left) *A Cat's Life*, *Beauty Sleep*, *Ben and Bill*, 2016
OPPOSITE: Kay McDonagh, *Angel Face*, *Devil Thoughts*, 2016

'Thousands of years ago,
cats were

WORSHIPPED

AS GODS.

Cats have never forgotten this.'

ANONYMOUS

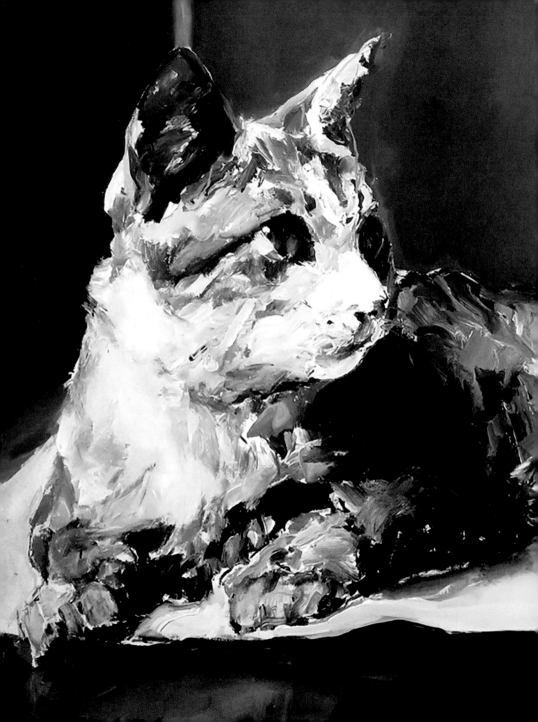

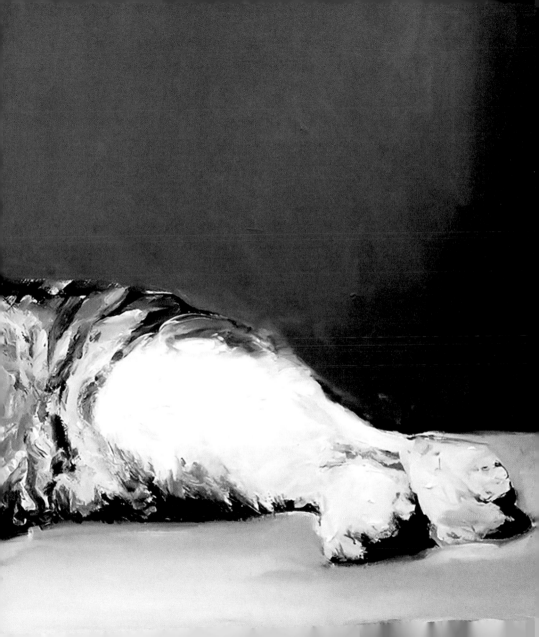

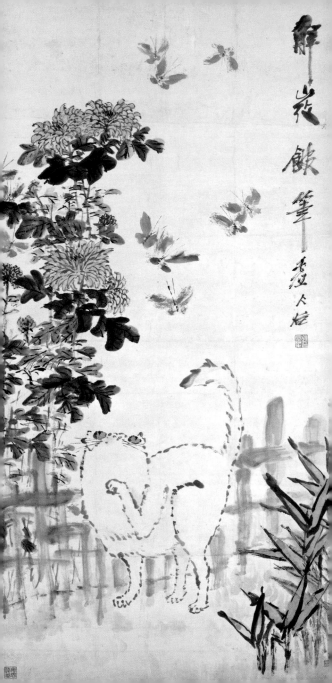

XU GU

Cat and Butterfly

Soldier-turned-painter Zhu Xubai experienced many disturbing events during his spell as an Imperial Army officer during China's violent Taiping Rebellion. He eventually saw the light, sympathized with the rebels and went AWOL, becoming a monk, changing his name to Xu Gu and working as an itinerant painter. Xu Gu sold his wares in China's heavily industrialized major cities such as Shanghai, Yangzhou and Suzhou. No wonder, then, that instead of recording the horrors that he had witnessed during the uprising for future generations, he spent his time painting gently nostalgic tableaux such as this one, with its beautiful blossoming chrysanthemums, kaleidoscope of fluttering butterflies and frog-featured cat.

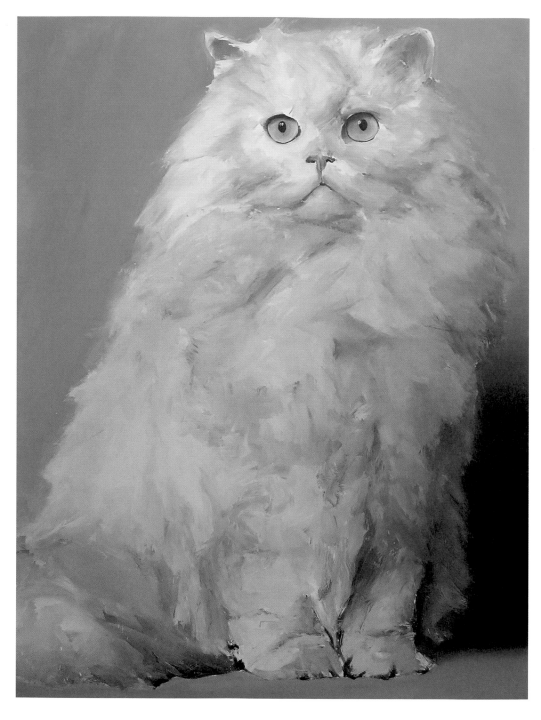

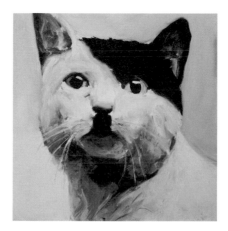

ABOVE: Santiago Ydáñez, *Untitled*, 2012
OPPOSITE: Santiago Ydáñez, *Untitled*, 2014
FOLLOWING PAGES: Tracey Emin, *Cat Watching*, 2006

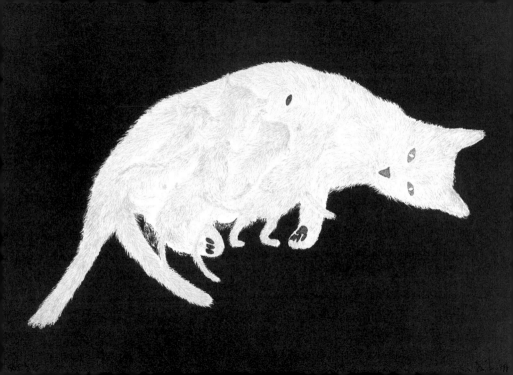

KIKI SMITH

Litter

1999

At first glance it would appear that there is only one cat in this painting (albeit with a few too many legs and tails), but closer scrutiny reveals a litter of five nursing kittens and their proud and protective mother. Cats are the most independent of our domesticated creatures, but the merging of cat and kittens in this picture reminds us of the kittens' complete dependence on their mother – they are born blind, deaf and without teeth. Creatures of habit from the very start (and unlike puppies, who like to shop around), kittens choose a feeding station to latch onto, and then stick with the same one until they are weaned. While this reproduction might suggest that this is a white cat, the artist has employed an exquisite and very expensive material – platinum leaf – because, of course, this lovely cat and her little kittens are worth it.

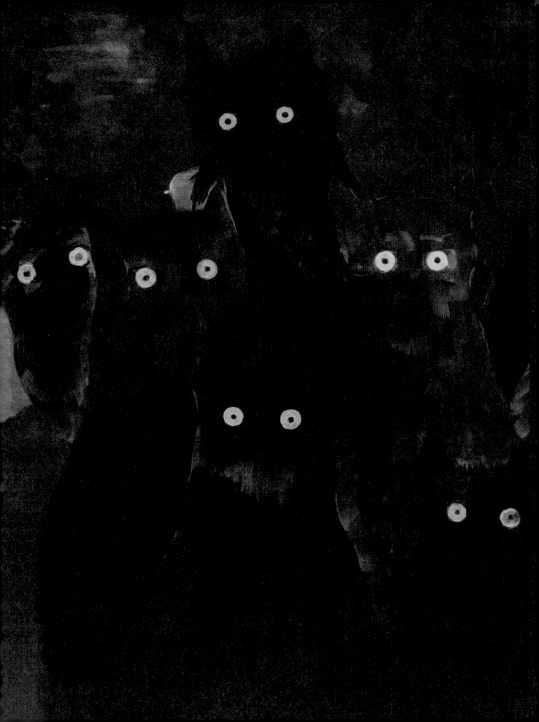

'One cat just leads to another.'

ERNEST HEMINGWAY

IT'S KNOWN AS A

'toothbrush moustache'

ACTUALLY.

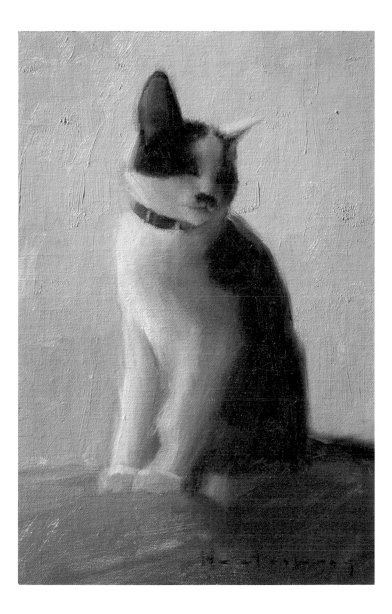

Aaron Westerberg, *Sen Sei, the Artist's Cat*, 2007

MORRIS HIRSHFIELD

Angora Cat

1937–39

Most people will associate Angora with the fur of the epony-mous rabbit, but it is also an ancient breed of cat originating from Turkey. Angora cats are described as having 'long, silky coats and elegant, sinuous bodies,' but either something has been lost in translation or this slightly boss-eyed example was blessed with none of these fêted breed attributes. Morris Hirshfield had no formal art training, but thanks to MoMA's (we imagine short-lived) policy of collecting and exhibiting self-taught artists, he was granted a solo show in 1943 after painting just 30 pieces. It was one of the most hated shows the museum ever put on, panned by the critics, and it led to the dismissal of MoMA's then director Alfred H. Barr Jr. However, Hirshfield was not without his fans: he was compared to the painter Henri (Le Douanier) Rousseau, and he had a high-profile admirer in the form of Dutch artist Piet Mondrian.

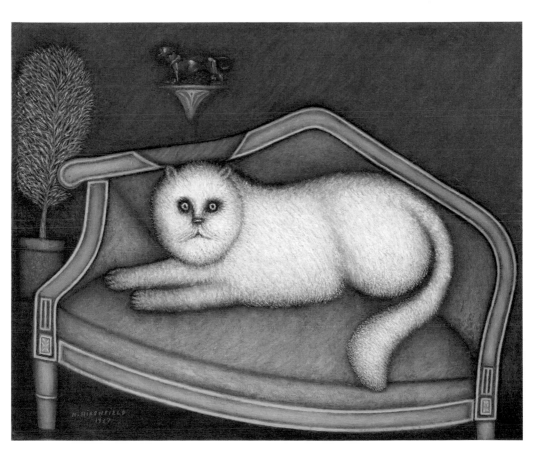

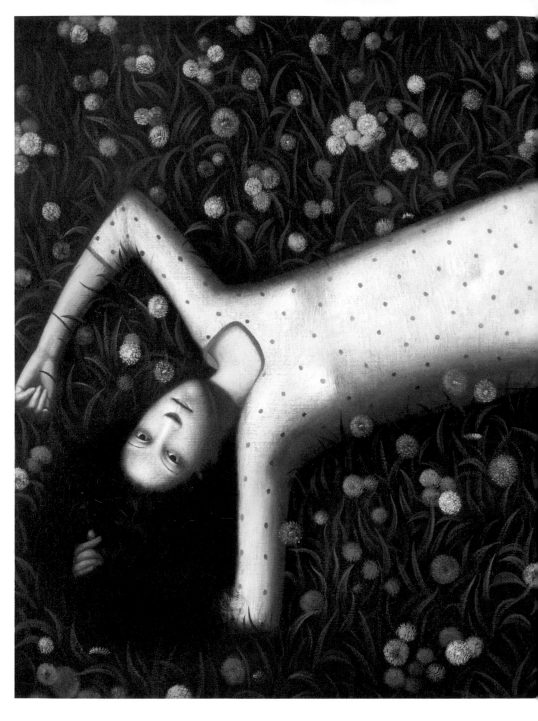

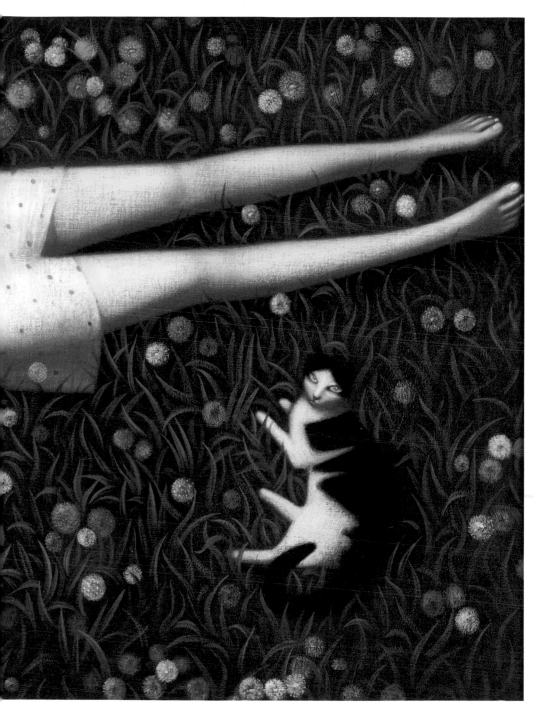

'Cats are living adornments.'

EDWIN LENT

OPPOSITE: Vania Zouravliov, *Lilin*, 2006
PREVIOUS PAGES: Vladimir Dunjić, *The Cat*, 2001

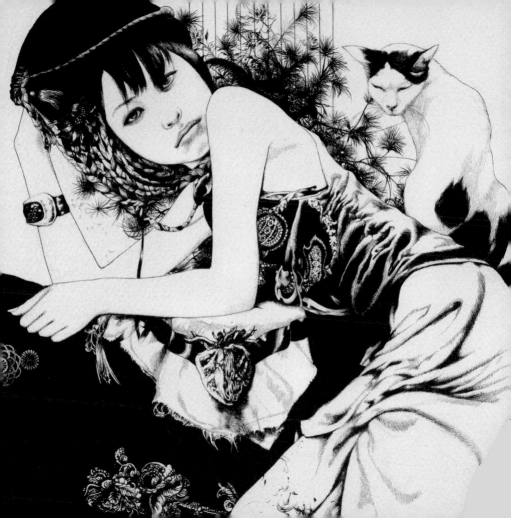

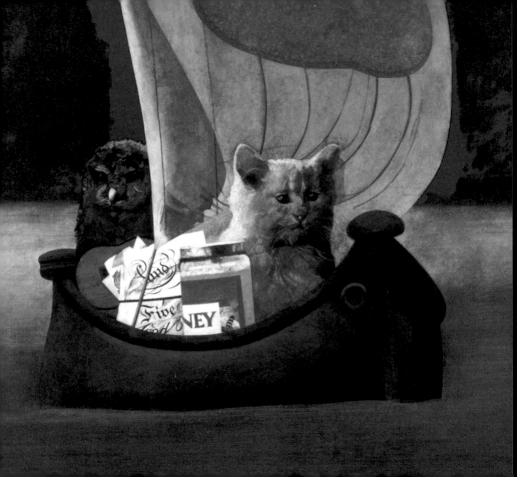

PETER BLAKE

The Owl and the Pussycat

1981–83

The Owl and the Pussycat went to sea
In a beautiful pea-green boat,
They took some honey, and plenty of money,
Wrapped up in a five pound note.

Published in 1871, Edward Lear's 'nonsense' poem 'The Owl and the Pussycat' is the tale of an endearing love story between a most unlikley couple. Lear was a true cat lover, and his beloved tabby cat Foss (who was reportedly the inspiration for 'The Owl and the Pussycat') features in many of his sketches and pieces of writing. Adopted when he was a kitten, the cat (described by Lear in one of his poems as being 'spherical') only had half a tail – apparently it was chopped off by a servant to stop him straying. Foss was Lear's faithful companion, and Lear was so attached to him that when he moved to Italy he asked his architect to replicate the layout of his previous house so that his feline friend would immediately feel at home. Foss reached the grand old age of seventeen and was given his own headstone at Lear's Villa Tennyson in San Remo. The pair were not long parted, as his owner died just two months later.

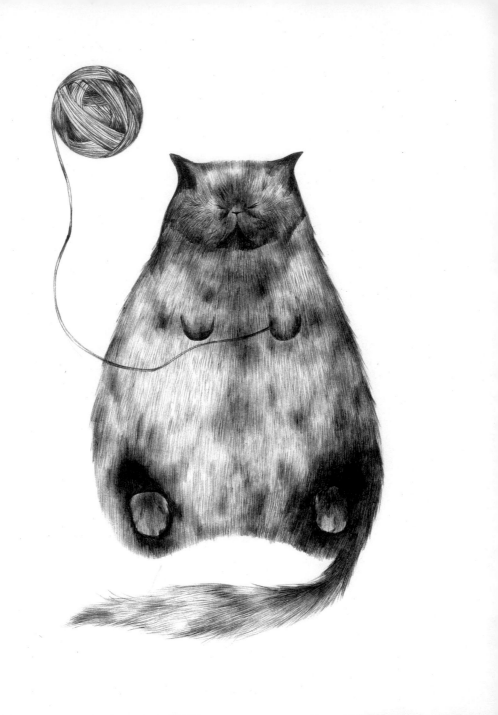

'THERE'S NO NEED FOR
A PIECE OF

sculpture

IN A HOME THAT HAS A

cat.'

WESLEY BATES

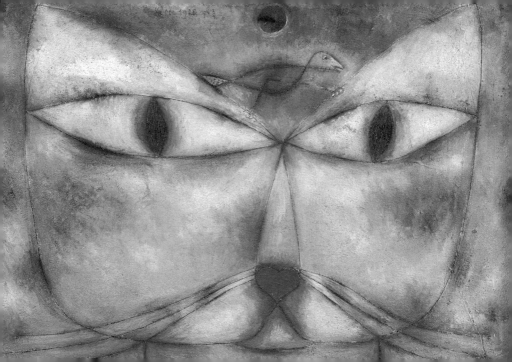

PAUL KLEE

Cat and Bird

1928

The first thing we notice about Klee's wide-eyed cat (painted while he was still a Bauhaus Master, five years before the school was shut down by the Nazis) is that it has something on its mind – a bird. The cat's enormous pupils are almost fully dilated, and we presume it's staring intently as it readies itself to pounce on its unsuspecting prey. After the disproportionately huge eyes, the next thing we notice about Klee's childlike representation is that the cat's nose has been replaced with a cute red heart. Instead of depicting the typical predator and its prey, maybe this jewel-like painting is actually showing us something very rare and infinitely more precious – a love affair between avian and feline? It's unlikely, but given the contrary streak that is very deeply embedded in the cat psyche, not completely impossible.

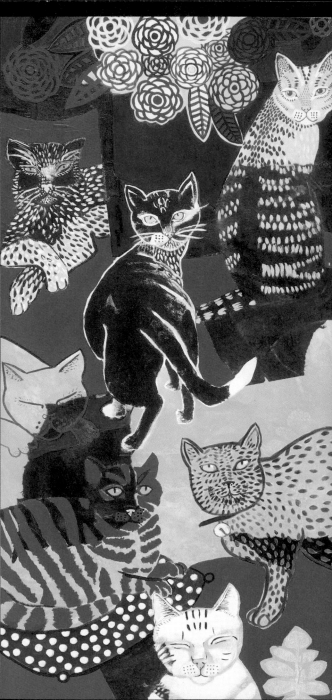

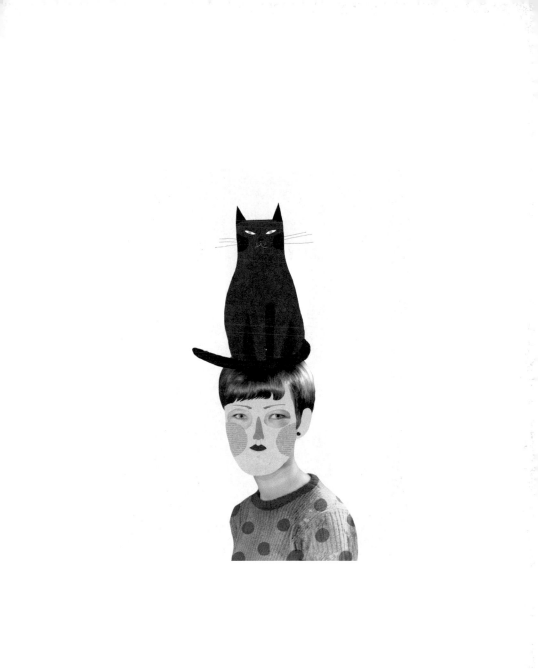

ABOVE: Mathilde Aubier, *Un gat en el cap*, 2016
OPPOSITE: Cate Edwards, *Seven Cats*, 2014

CHRISTOPHER WOOD

Boy with Cat

The 'boy' in question is Wood's friend Jean Bourgoint, and, although Wood did have relationships with men, it was actually Jean's striking sister Jeanne with whom he had a tempestuous affair. The sitter and the Siamese cat in this picture have much in common – refined, elegant and with piercing blue eyes, they both look slightly uncomfortable. Darlings of the 1920s Parisian literary set, the Bourgoint siblings were said to be the inspiration for the brother and sister featured in Jean Cocteau's novel *Les Enfants Terribles*. Wood painted Jeanne the same year (1926), also sitting crossed-legged but with a (presumably) dead fox on her lap. Despite being a talented painter, Wood cut a rather troubled (if very bohemian) figure, succumbing to opiates and throwing himself under a train at Salisbury station just a year after painting this very beautiful but very dysfunctional pair.

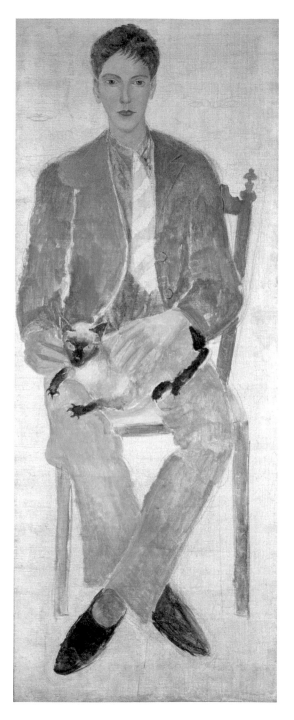

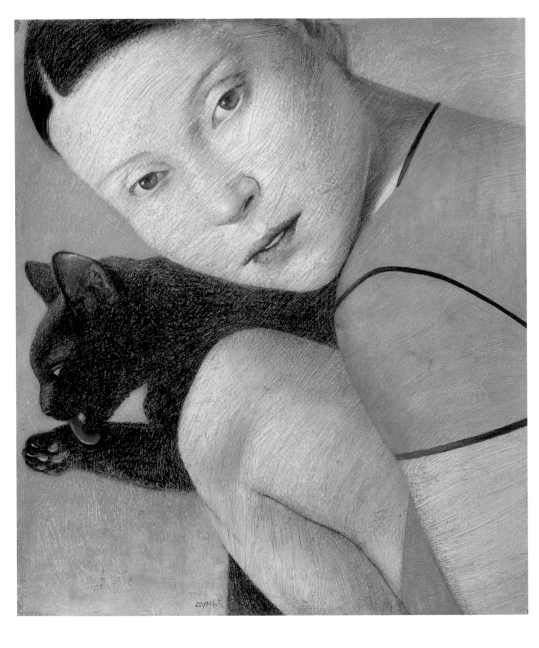

Vladimir Dunjić, *Last Cat's Life*, 2015

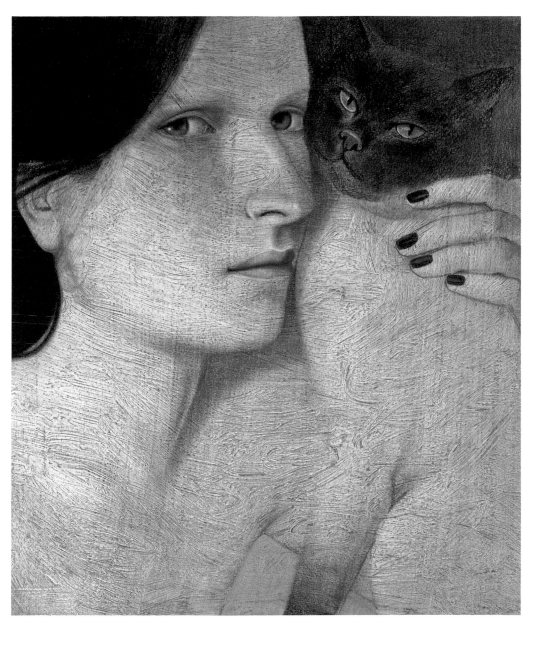

Vladimir Dunjić, *The Siamese*, 2014

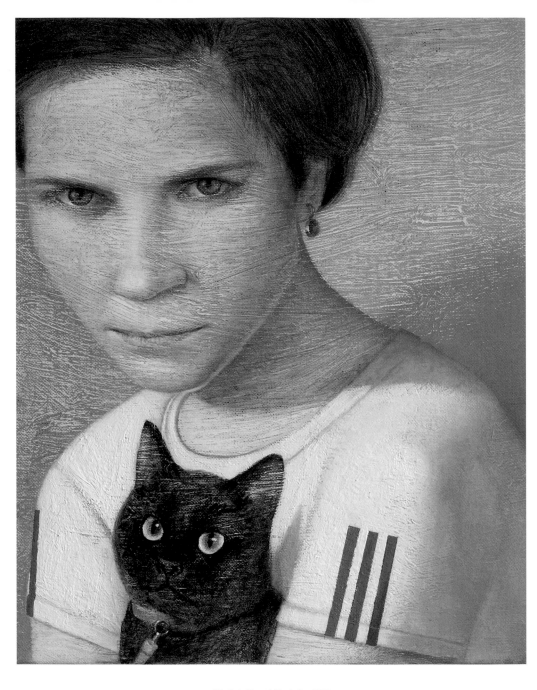

Vladimir Dunjić, *Black Cat*, 2015

'Women and cats

will do as they please, and

MEN AND DOGS

SHOULD RELAX AND
GET USED TO THE IDEA.'

UNKNOWN

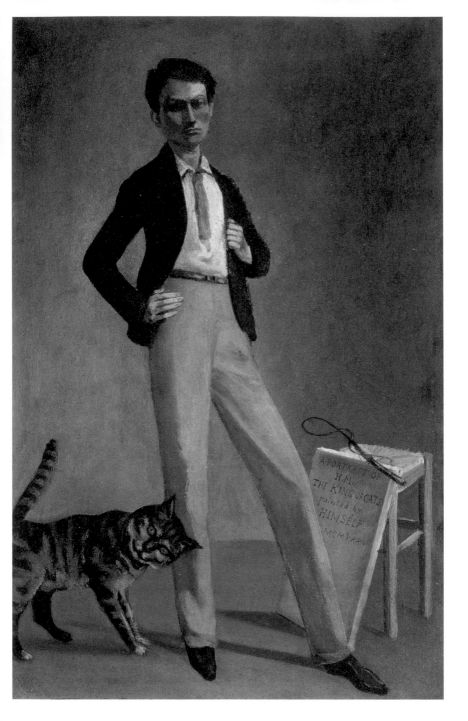

BALTHUS

Self-Portrait: His Majesty the King of Cats

1935

Balthus (born Balthasar Klossowski de Rola) had a fascination with cats throughout his life. In 1921 he published *Mitsou*, a book chronicling the story of a young man and his cat. He later made his name with a series of rather questionable paintings of young girls such as *The Guitar Lesson* (1934). Part of the Paris literary set and admired by artists such as Picasso, the elongated pro-portions of the self-styled 'King of Cats' and his adoring feline companion make this painting more akin to a fashion plate than a realistic self-portrait. Balthus' subject matter always attracted controversy; however, it would appear that he consciously culti-vated his enigmatic rock star image, mixing with models, royals and minor celebs. This carried on throughout his life and even beyond – he was blessed with the rather dubious honour of hav-ing Bono from U2 sing at his funeral.

TSUGUHARU LÉONARD FOUJITA

Self-Portrait in the Studio

1926

With his striking appearance and love of art, women and cats, Foujita must have made quite an impression when he arrived in Paris from his native Japan in 1913. He soon became one of the city's most famous artists, mixing with the likes of Léger, Braque, Modigliani et al, and cut quite a dash with his horn-rimmed glasses, wristwatch tattoo, statement jewellery and flowing Greek-style tunic. He clearly had a wicked sense of humour, as he occasionally wore a lampshade on his head, claiming that it was part of his 'national dress'. Foujta provided 20 exquisite illustrations for Michael Joseph's poems in *A Book of Cats*, which was published in 1930 in an edition of 500. If you ever happen to come across a copy in the corner of a dusty secondhand bookshop for less than the price of a decent-sized family saloon, then pay up immediately and run before someone discovers that you've just purchased a very rare copy of one of the most precious books about cats ever made.

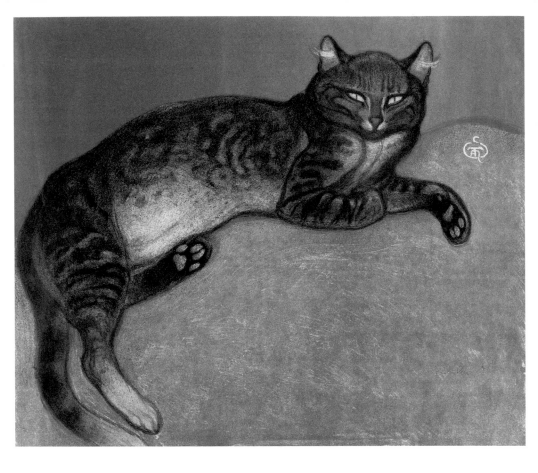

ABOVE: Théophile Alexandre Steinlen, *Chat allongé*, 1909
OPPOSITE: Suzanne Valadon, *Bouquet and a Cat*, 1919

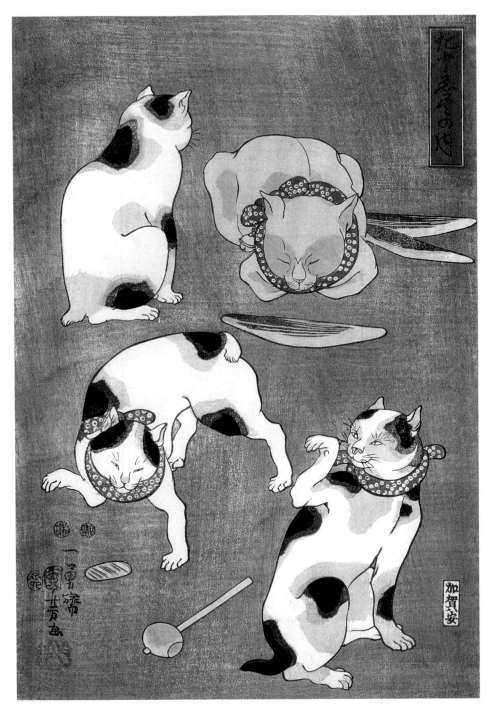

UTAGAWA KUNIYOSHI

Cats Illustrating Various Proverbs (detail)

1852

As a nation, the Japanese have long been obsessed with cats – from the delicate paintings of the Edo period, right through to the ubiquitous cartoon Hello Kitty, cats have continued to play an important part in Japanese culture. Utagawa Kuniyoshi is considered by some as the godfather of modern cat imagery in Japan. His charming studies show cats in many different guises – with geishas, as human characters, as letters of the alphabet, and here, where they are used to illustrate various Japanese proverbs. Many cat owners will recognize the face-to the-wall pose used to depict the proverb at the top left of the picture. 'Neko wo kaburu' roughly translates as 'Wear a cat' – however, rather than encouraging the donning of a feline fur coat, it's simply a warning not to reveal one's true nature.

'The problem with cats is that they get the same exact look whether they see a moth or an axe-murderer.'

PAULA POUNDSTONE

ÉDOUARD MANET

Le rendez-vous des chats

1868

Cat lover Manet's black and white puss Zizi appears in many of his paintings, sometimes as herself (as in the 1880 painting *Woman with a Cat*), and sometimes in disguise. This drawing shows a meeting of two cats on the rooftops of Manet's Belle Époque Paris. The delicate white female cat has just strolled past the handsome male cat – her uplifted tail is saying hello, and his question mark-shaped tail speaks for itself. Both are looking back over their shoulders, checking each other out. A rendezvous involves a predetermined meeting, and making (or keeping) an arrangement is of course not something that a cat would ever do. With this charming drawing, Manet has simply shown himself to be an old romantic, projecting this random rooftop feline meeting as a gently flirtatious encounter between a man and a woman.

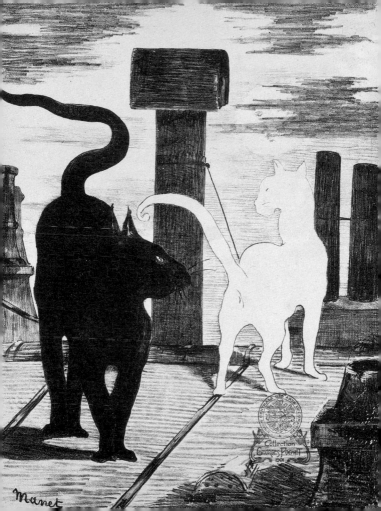

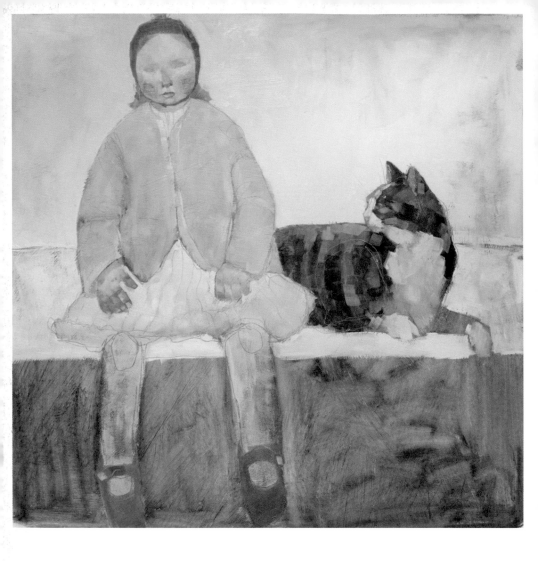

ABOVE: Olivia Pendergast, *Amadi and Lily*, 2014
OPPOSITE: Olivia Pendergast, *Ella Rose and Marzipan*, 2014
PREVIOUS PAGES: Dame Elizabeth Blackadder, *Amalia Sleeping*, 2004

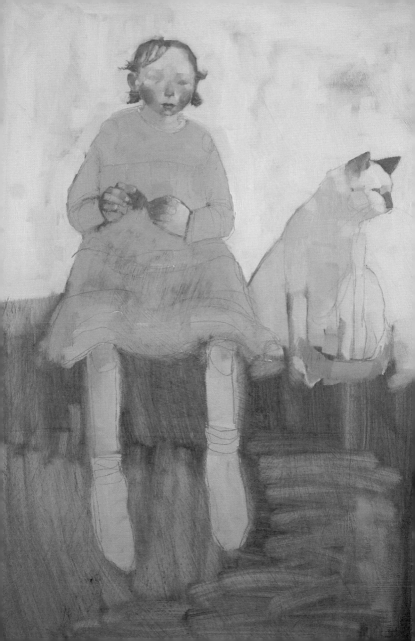

CHRISTOPHER NEVINSON

Le Chat

c. 1920

After emerging as part of the Futurist movement in London, C.R.W. Nevinson (as he was often known) travelled to France at the beginning of World War I, working in the makeshift hospital for French troops known as 'The Shambles' and driving ambulances for a while. What he witnessed had a profound effect on him; he painted many of these disturbing scenes on his return, eventually becoming an official war artist in 1917. While Nevinson is best known for his powerful images of conflict, this lithograph featuring a silhouette of a black cat with its tail curled around itself is charmingly domestic and mundane. In contrast to this, Nevinson was clearly someone who stirred up strong feelings – in 1920, critic Charles Lewis Hind remarked that 'It is something, at the age of thirty-one, to be among the most discussed, most successful, most promising, most admired and most hated British artists.'

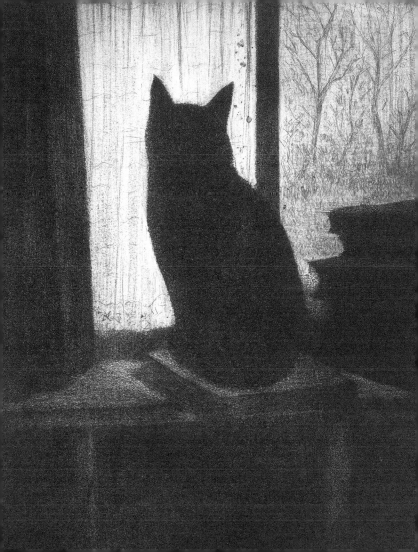

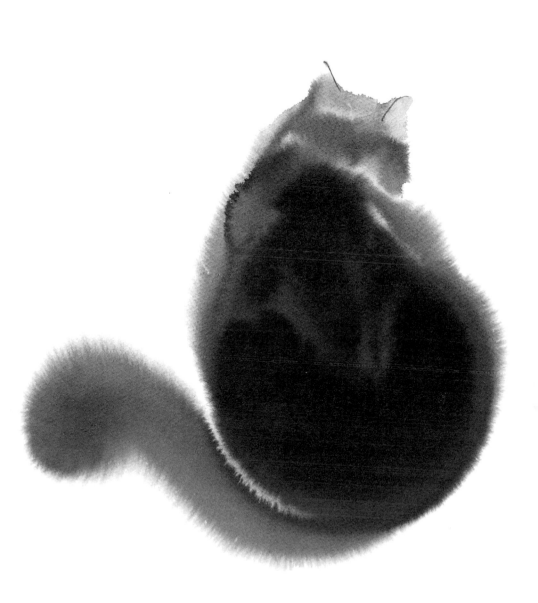

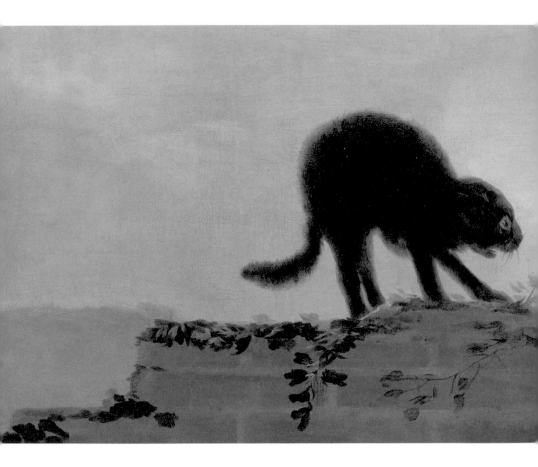

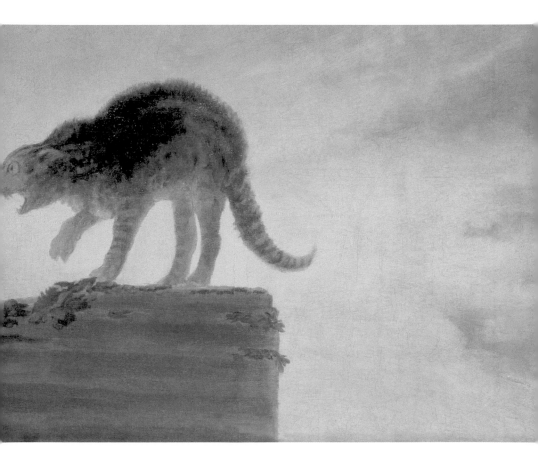

ABOVE: Francisco Goya, *Riña de gatos* (*Cat Fight*), 1786–87
PREVIOUS PAGES: Endre Penovác, *Tranquility*, 2015, and *Excited*, 2014

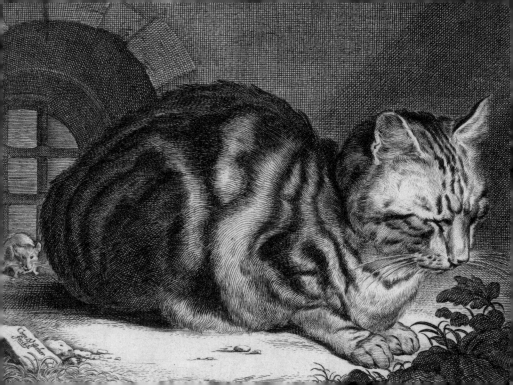

CORNELIS VISSCHER

The Large Cat

c. 1657

Don't be fooled into thinking that this engraving portrays a gently snoozing cat, blissfully unaware of the cute dormouse sneaking up behind him. While his eyes might be closed, his ears show that he is on full alert, ready to pounce just when the little mouse thinks it's safe. The antagonistic relationship between cat and mouse is as old as the hills, and it could be said that this engraving represents the seventeenth-century version of the most famous cat and mouse pairing, that of Tom and Jerry. While the cartoon couple relentlessly attacked each other with a variety of implements, neither ever came to any permanent harm. And while they would never be described as friends, there were rare occasions (such as when a baby escaped in the 1958 episode *Tot Watchers*) when the pair (albeit temporarily) found themselves united in a common cause.

EDWARD BAWDEN

Cat among Pigeons

1986

Cats appear in many of Bawden's pieces, and it would seem that he owned quite a few over the years. In 1930 his great friend Eric Ravilious painted Bawden at work in his rather fancy studio; sitting on a rug just behind the artist, a ginger cat is getting down to the serious business of deep cleaning. In this picture, painted in the hallway of his house in Saffron Walden some 56 years later, Bawden is having fun with the playful title, which must have been the motivation for this charming piece. The pigeons appear on the very decorative wallpaper (designed by Bawden himself), and Bawden's black cat (which is staring fixedly at the artist) is of course blissfuly unaware of being surrounded by the feathered flock. Given that the name of the wallpaper is 'Wood Pigeon, Church & Dove', it could be suggested that the title should actually be *Cat among Pigeons…and Doves.*

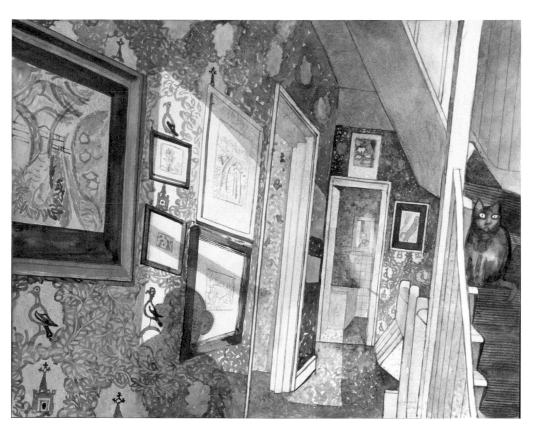

Is anything better than a warm, comfy lap?

Two warm, comfy laps...

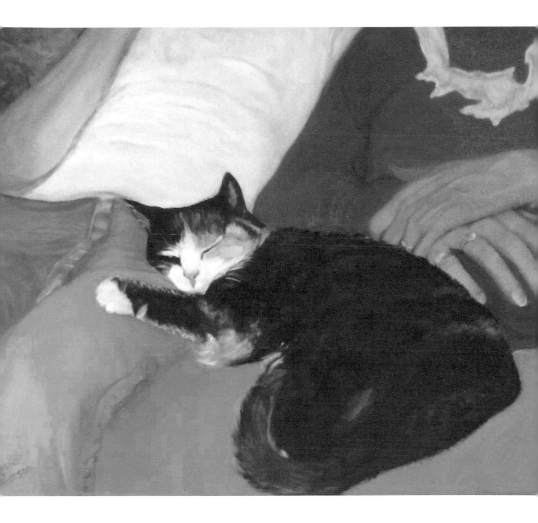

Teressa Pearson, *Picasso Cat*, 2006

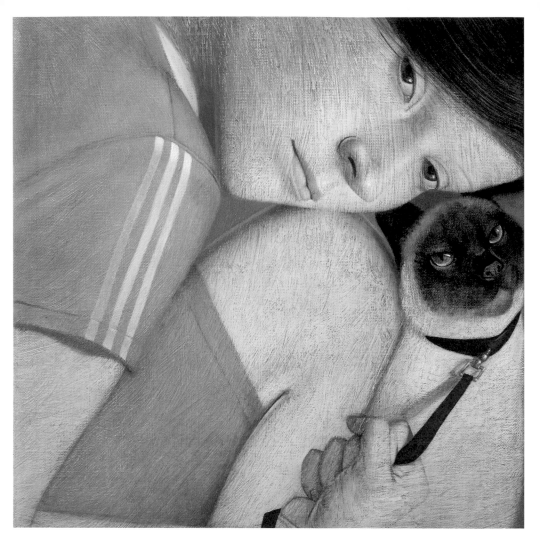

Vladimir Dunjić, *Blue Leash*, 2015

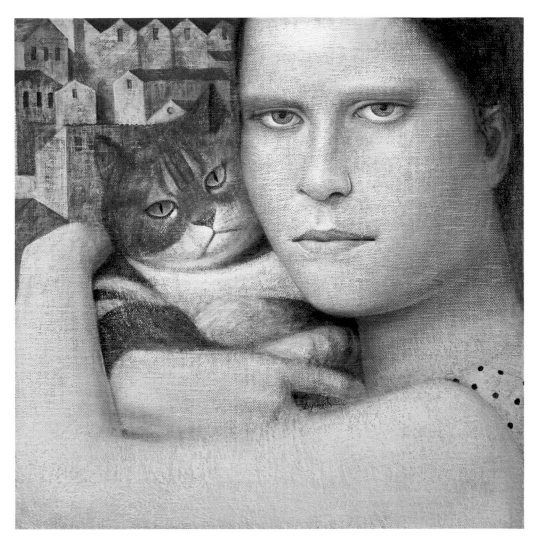

Vladimir Dunjić, *The Sixth Life*, 2009

AMMI PHILLIPS

Girl in a Red Dress with Cat and Dog

—————————————— 1830–35 ——————————————

Now residing in the American Folk Art Museum in New York, Ammi Phillips' work wasn't always quite so revered. The Connecticut-born jobbing portrait artist sank into obscurity after his death, and it was only through some nifty detective work that the full extent of his output was eventually revealed several decades later. This slightly stroppy-looking girl protectively cradling her white cat looks like she can't wait to get out of her stiff red dress with its enormous puffball sleeves. The anonymous sitter has had a life beyond that of Phillips' beautifully observed portrait, however: in 1998 she appeared on a US postage stamp, and in the same year, author Nicholas B. Nicholson was so intrigued that he penned a story told from her perspective – the rather unimaginatively titled *Little Girl in a Red Dress with Cat and Dog.*

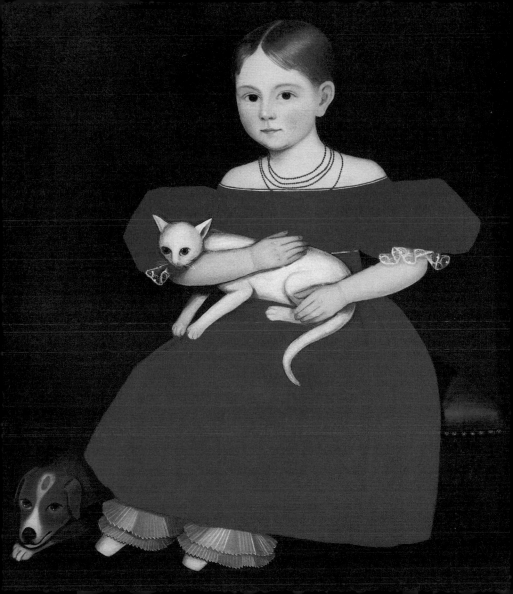

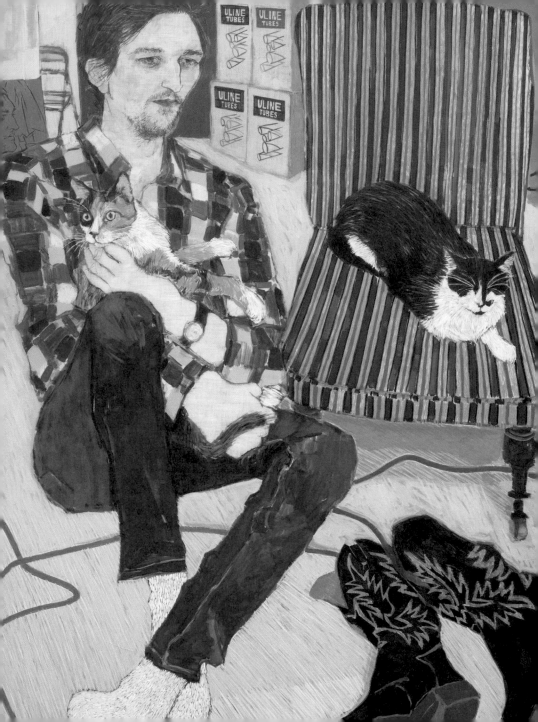

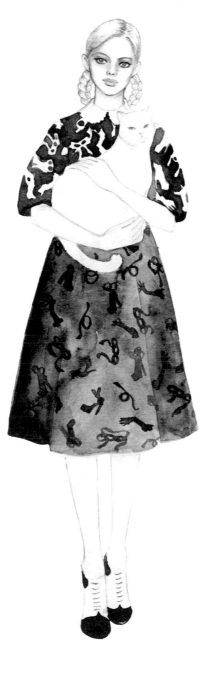

ABOVE: Teri Chung, *Green Eyes*, 2011
OPPOSITE: Hope Gangloff, *Must Seriously Love Cats (Greg Lindquist)*, 2015

CREDITS